Vermeer's Secret World

Adventures in Art

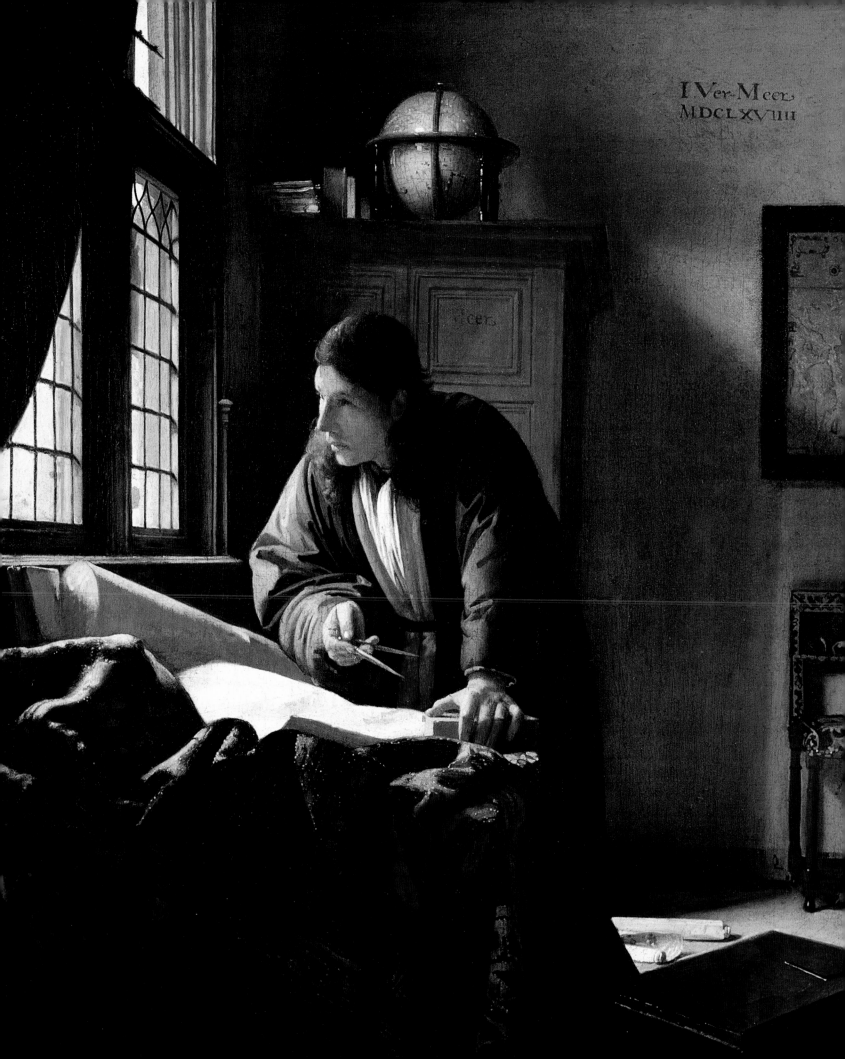

Vincent Etienne

Vermeer's Secret World

Adventures in Art

"He is an enigma in an age where nothing resembles him and nothing can explain him."

Marcel Proust

Prestel

Munich · Berlin · London · New York

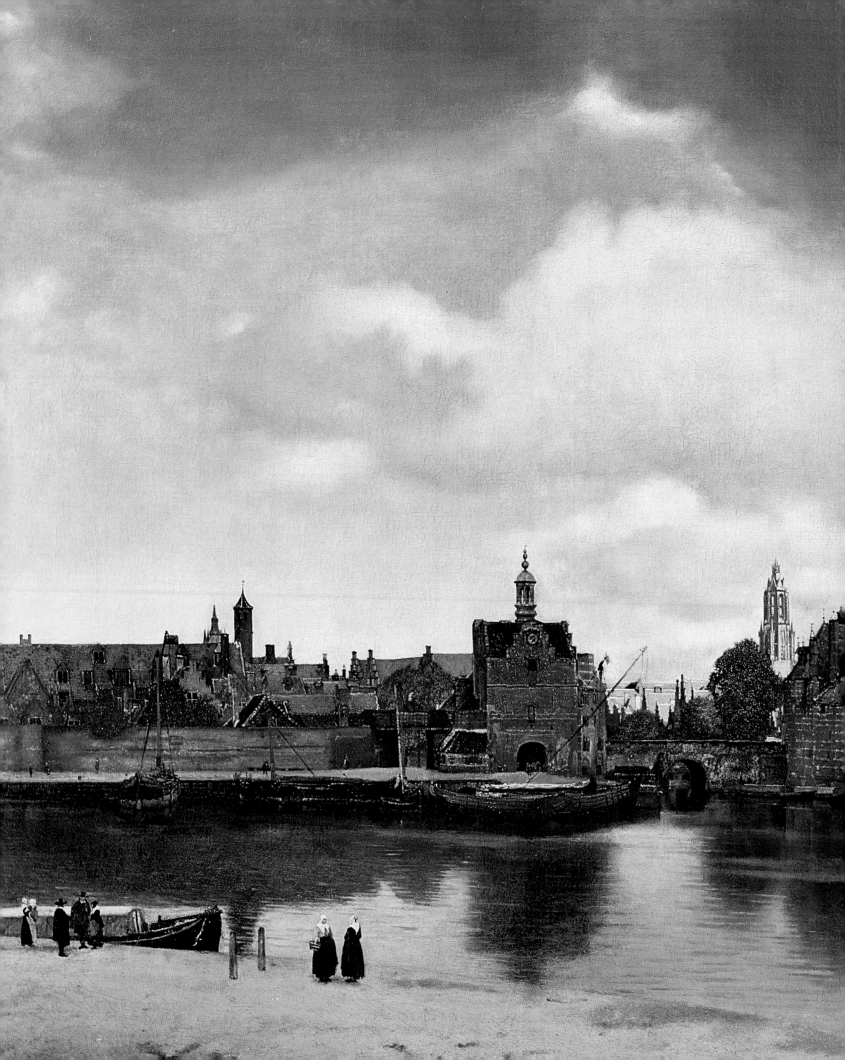

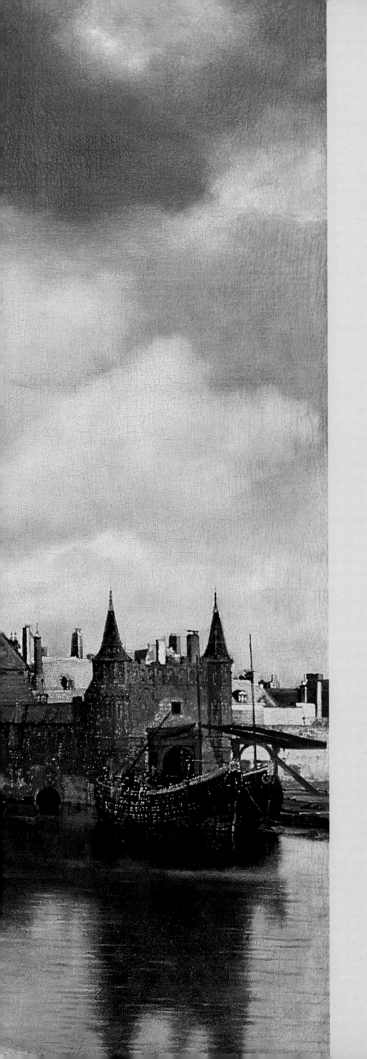

The Stillness of the Town

Jan Vermeer spent his entire life in Delft, in the Netherlands. While many painters of this period, for instance Pieter de Hooch and Adriaen van Ostade, chose to represent the hustle and bustle of street life, Vermeer's townscapes are steeped in an atmosphere of silence, suffused with tranquility.

A few figures chatter on the yellow triangle of the river bank. The horizon is traced by the line of the rooftops, whose colors alternate between warm tones and cold tones. The dense clouds and the reflections of the buildings in the water create an impression of depth. The eye is drawn to the distant roofs in the center of the painting, which are bathed in sunlight. In this view of Delft, where time seems to have come to a standstill, Vermeer creates a sense of calm and serenity.

View of Delft, c. 1660/61

Scenery and Staging

Vermeer's domestic scenes are worked up slowly. The painter labors over every detail, taking time to position his models and arrange his props. Here, the plain background of the wall, with only a map hanging on it, contrasts with the few objects scattered on the table: a piece of blue cloth, a ribbon tumbling out of a jewelry box, a pitcher standing in a gilded basin.

The eyes of the young woman are demurely lowered and her face is illuminated by sunlight which is also reflected in the jug. She looks pensive, as if hesitating over a decision that must be made. She holds the handle of the pitcher as if getting ready to use it, but she seems distracted by an incident taking place beyond our view. Has someone called her? Has she heard a noise?

Young Woman with a Water Pitcher, c. 1662

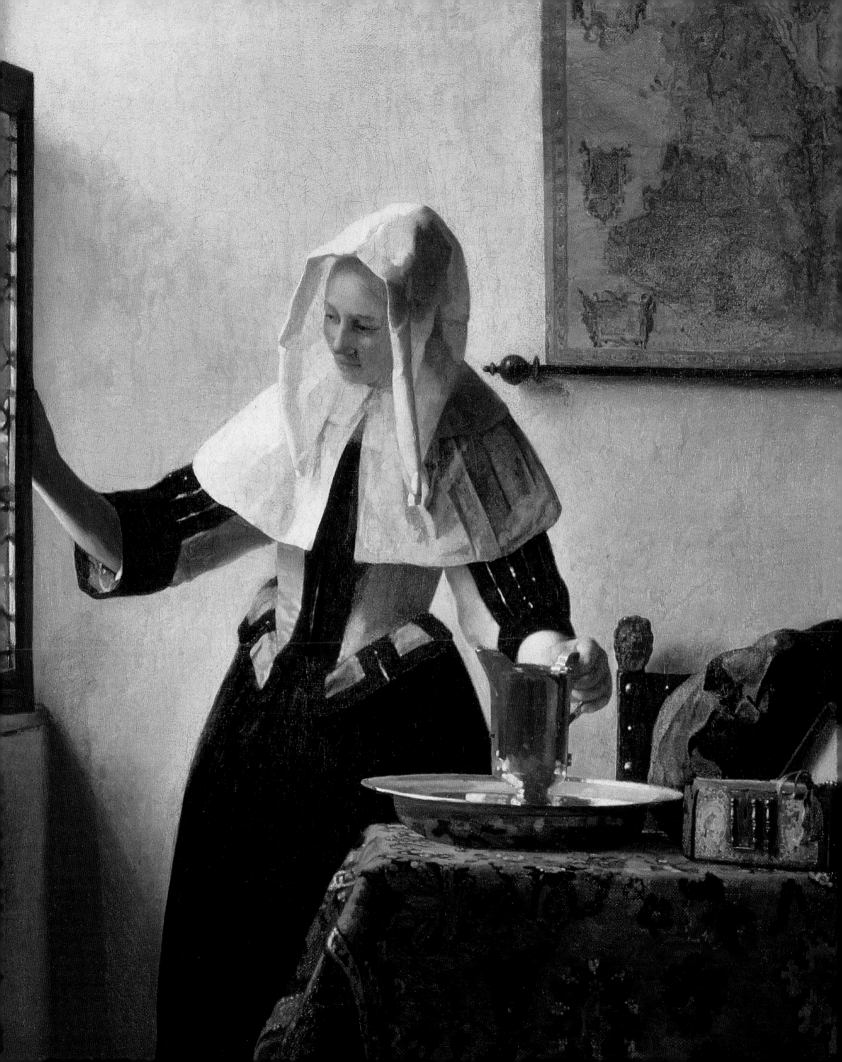

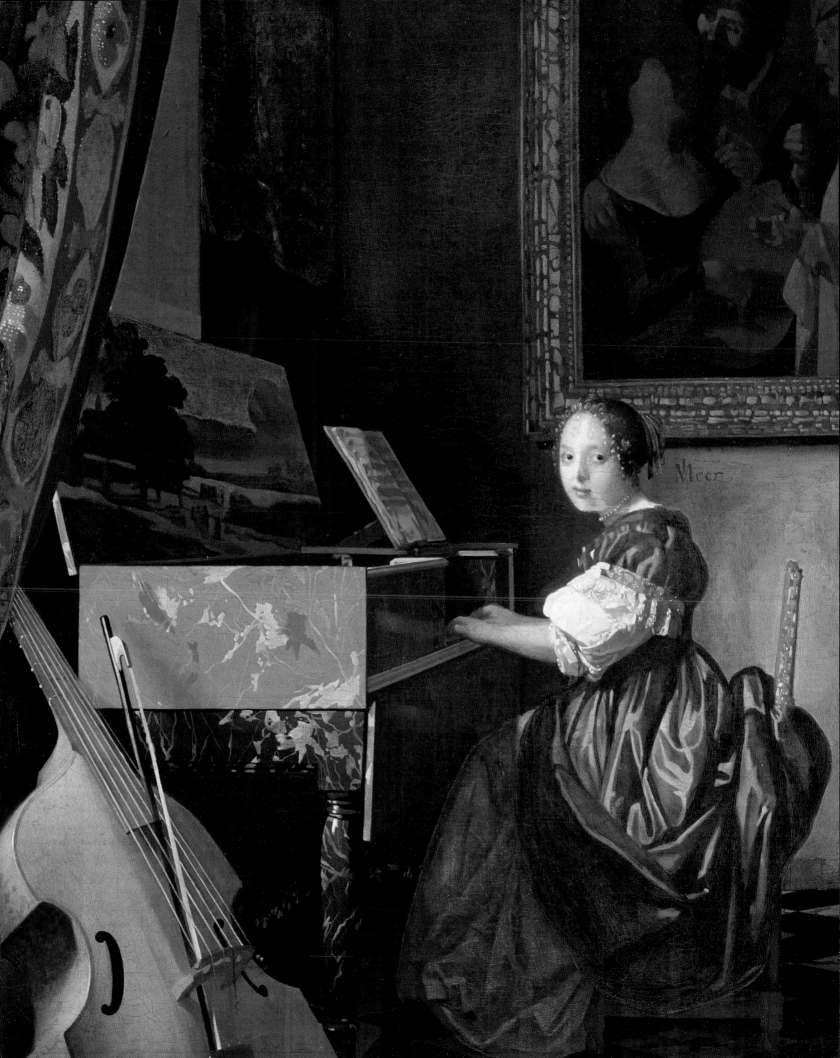

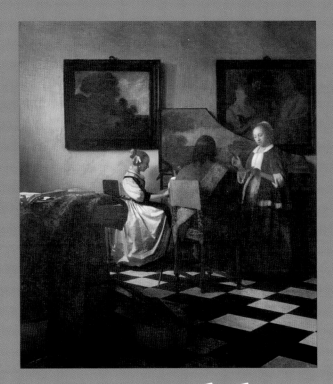
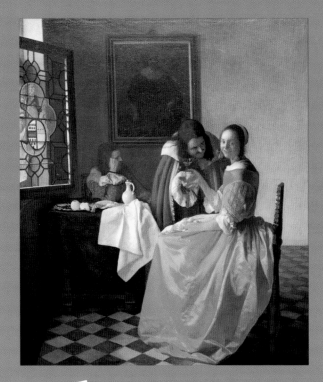

A World Turned Inwards

A gilded or porcelain pitcher, a viol or a little harpsichord decorated with a land-
scape, or perhaps a blue or yellow coat edged with white ermine... Vermeer very
often reproduces the same objects. In *The Concert* and *A Young Woman Seated at
a Virginal* the same painting is visible on the wall. The carpets and hangings on the
table recall the taste for the Orient that was very much in vogue at that time and
remained the privilege of the wealthiest members of society. The women's dress,
as well as the floor tiles, the paintings and the musical instruments are further signs
of a middle-class home. Sometimes Vermeer depicts at the base of a wall a frieze
of blue-and-white tiles that are so characteristic of Delft.
The sets change very little, and Vermeer no doubt depicts his own furniture in his
paintings. These many references lead us into the very personal realm of the painter,
a world turned inwards on itself.

A Young Woman Seated at a Virginal, 1672 *The Concert, c. 1658/60* *The Girl with a Wineglass, c. 1659/60* 7

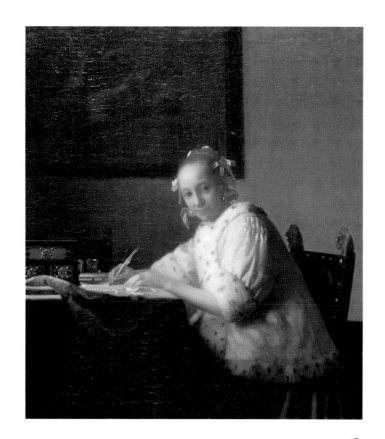

An Unsettling Invitation

Their heads turned towards us, these two young women observe us with curiosity. A certain wariness can be read in the eyes of the keyboard player, while the face of the young woman writing a letter seems affectionate and mischievous. Interrupted in what they are doing, they seem frozen, as if someone had just walked in on them. Both of them are motionless, but their expressions of surprise are obviously feigned. With a pen in her right hand, the young woman looks at the viewer quizzically and seems to want to go back to writing the letter that is partly covered up by her other hand. Vermeer has painted a "fake snapshot", depicting a scene in which the action is suspended, unreal, where we have to guess at what might have been happening. But even if these two young women appear to be inviting us to join them, we are still no closer to penetrating the mystery that surrounds them.

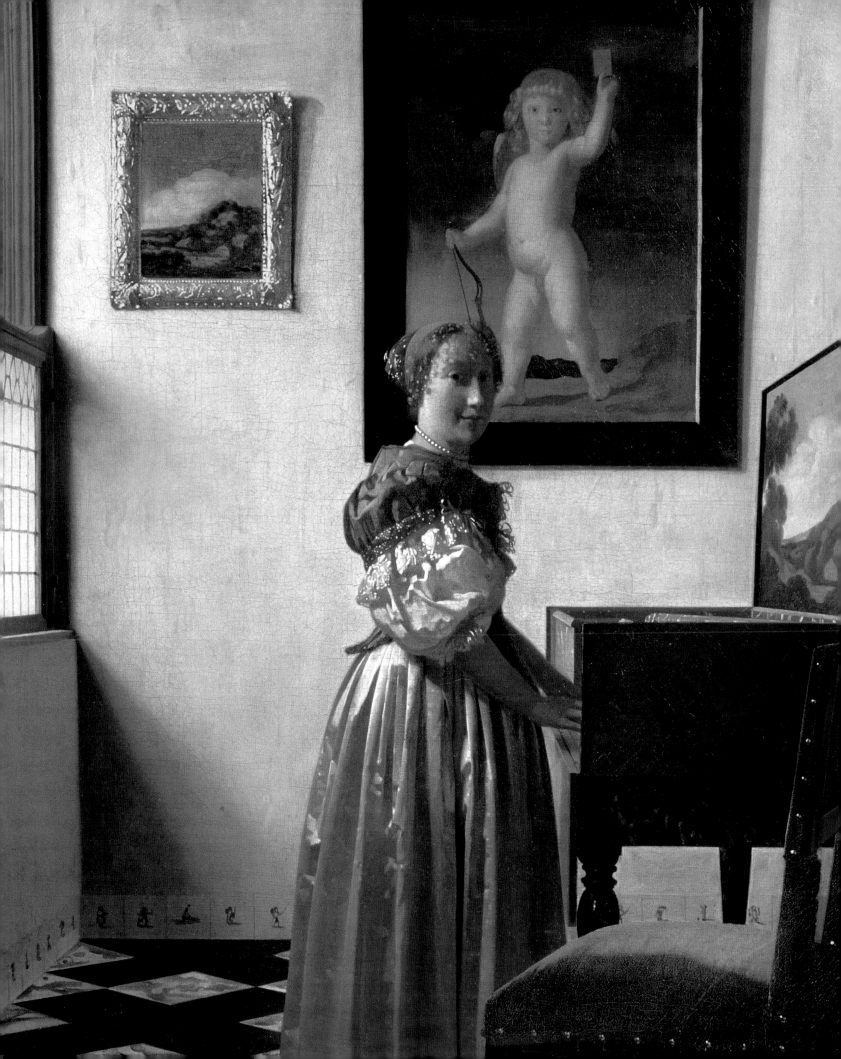

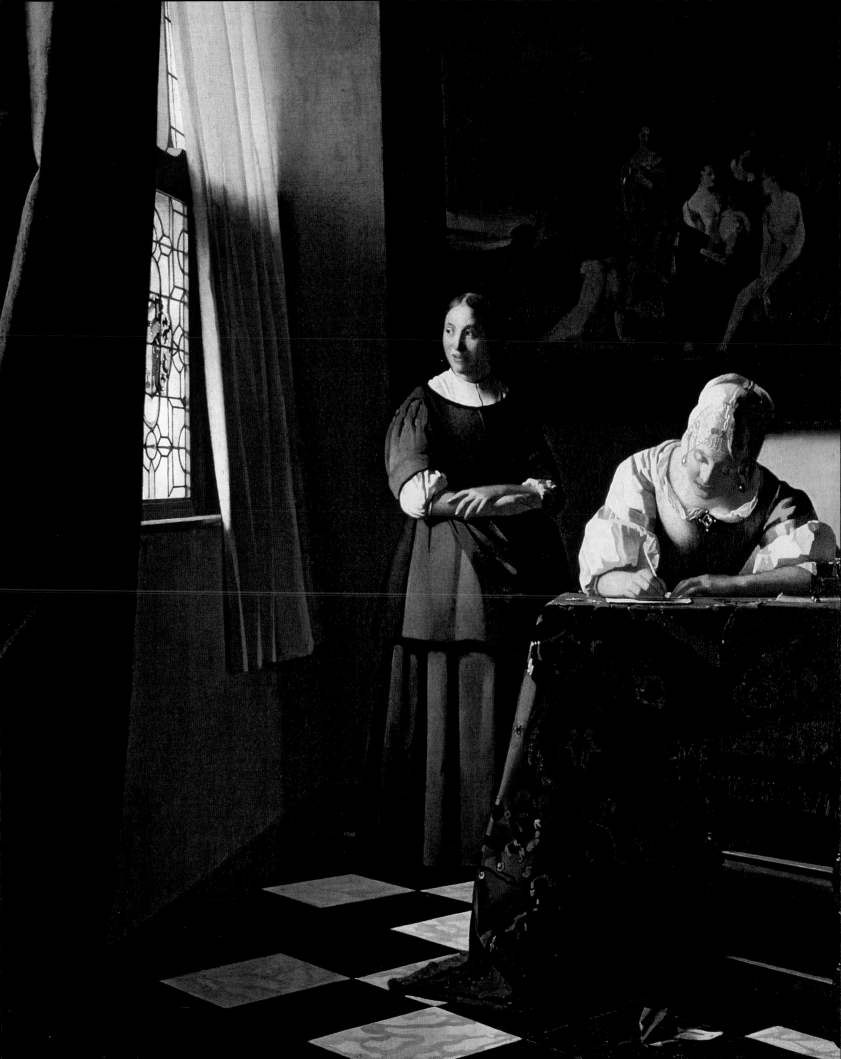

The Play of Light and Shadow

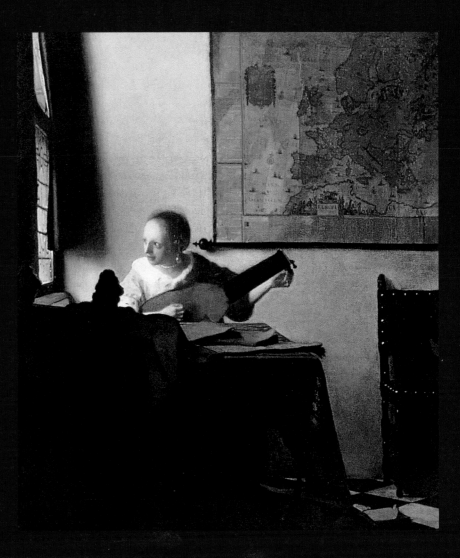

In the half-light of the room, time seems once again frozen. The luteplayer, her face turned towards the window, tunes her instrument in silence. The light follows a diagonal path and is reflected in the pearl that she wears in her ear. The rest of the room is in shadow, and the viola da gamba lying on the floor is barely visible. Light isolates the sitter, bathing her in a soft and diffuse glow.

By placing a drape at the window, Vermeer creates an effect of transparency. The use of *chiaroscuro* makes the brighter tones stand out against the darker ones and focuses the onlooker's gaze by concealing certain forms. With her arms folded, the maidservant remains in the background and seems to be daydreaming, waiting patiently for the letter that her mistress is absorbed in writing. What surrounds these women is of little consequence – the only thing that counts is their faces, which are wreathed in light.

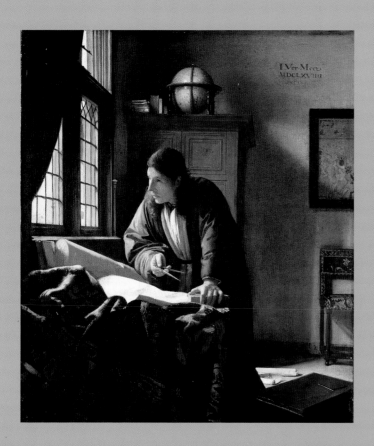

The Earth and the Heavens

With these two canvases Vermeer takes up a theme that was very popular in seventeenth-century Holland. Pictured in their studies, the astronomer and the geographer are deep in concentration. The use of cold tonalities, dominated by greens, yellows and blues, emphasizes that atmosphere of austerity which is so conducive to work. The scene is very staged, very artificial. Vermeer has depicted the instruments that traditionally symbolize their disciplines: a celestial globe, a sundial, an astronomical treatise, a pair of compasses and some geographical maps. The two scholars seem to be on the point of making a major discovery. Leaning on the table, compasses in hand, the geographer stares into the distance. The astronomer is about to spin the celestial globe in front of him but it is as if he has been stopped in his tracks. Together these two figures stand for the exploration of the earth and the heavens, the known and the unknown.

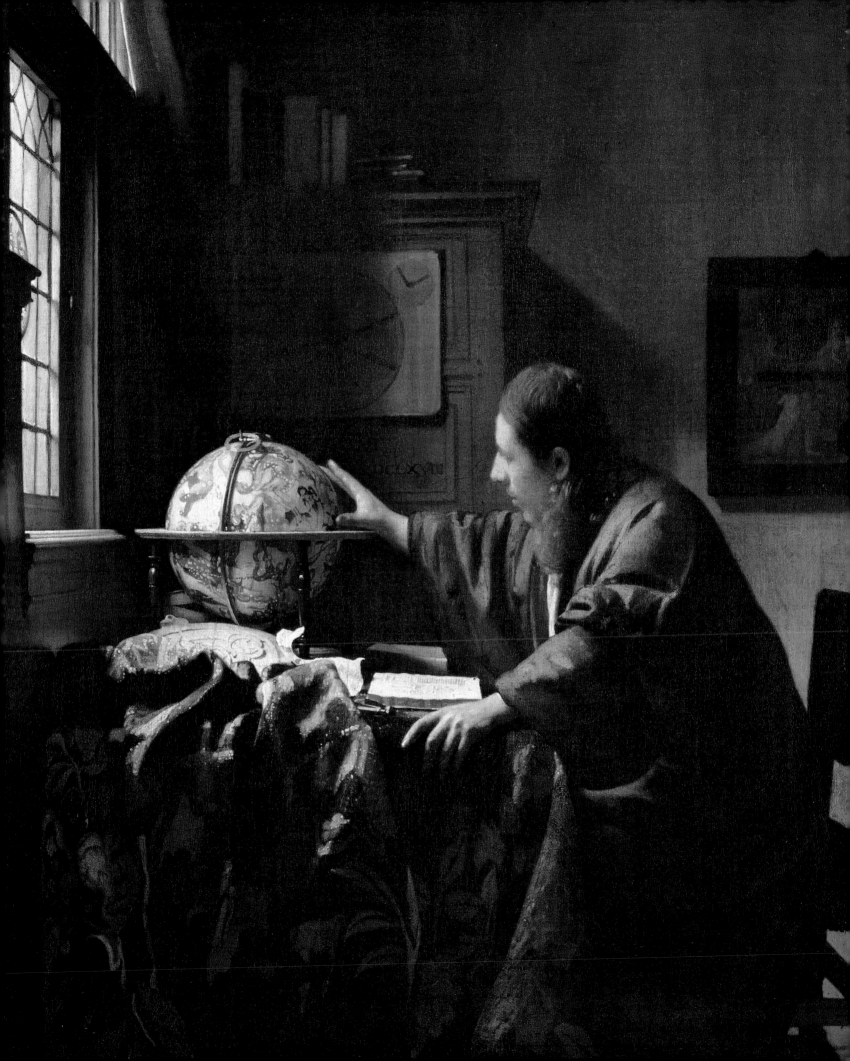

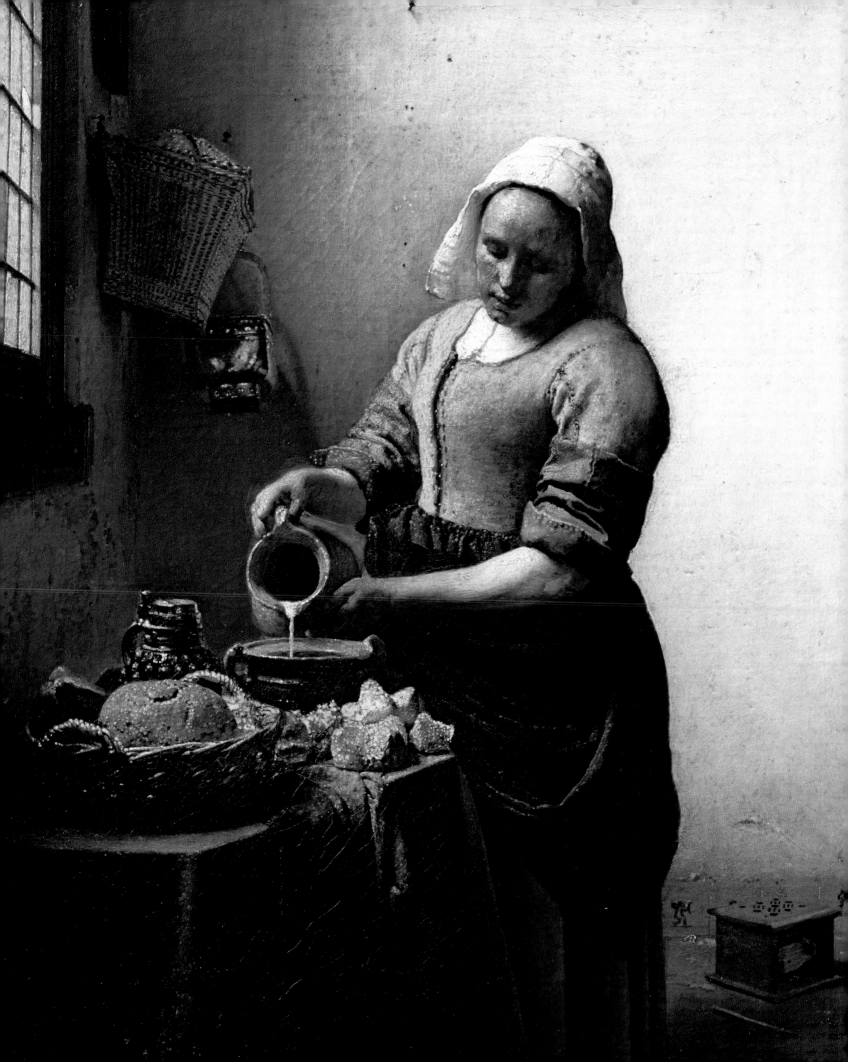

Work Time

One of Vermeer's favorite pigments is lapis lazuli, an ultramarine blue which is so intense that the other colors he uses pale in comparison. He combines it harmoniously with the very limited shades of his palette, a palette that has few bright colors but often includes tones that come close to yellow, ocher, brown or gray.

With her blue apron and yellow blouse, the stout milkmaid slowly pours a trickle of milk into a basin. In front of her, the roughly torn pieces of bread and the cloth on the table echo the coloring of her clothes, their strong hues contrasting sharply with the gray of the wall. Her generous curves convey the vigor of a woman who has devoted herself entirely to her work. This maidservant radiates a feeling of serenity, almost of contemplation. She pours the milk in the same way that grains of sand run through an hourglass. With her, time seems eternal.

The Milkmaid, c. 1658/60

Young Girls
and
Pearls

In earrings, as a necklace, worn in the hair or simply placed in a jewelry box or on a table, pearls recur frequently in Vermeer's work. By adorning his young women with this precious jewel, the painter brings out their beauty. But Vermeer's depiction of exalted beauty often has moralizing undertones. In fact *Woman with a Pearl Necklace* takes up the then common theme of Renaissance *vanitas* paintings and conjures up an image of idle and ephemeral beauty. Seen in profile, the young woman pulls together the ribbons of her pearl necklace. She studies her reflection in the mirror facing her, a secret reflection that we are not party to – and which nothing will tear her away from. The window is closed, and the curtain that is pulled across it adds to the sense of intimacy. Vermeer's paintings often have a hidden meaning: just as music or wine suggest chivalrous love, so pearls are an allusion to the narcissism and vanity of women.

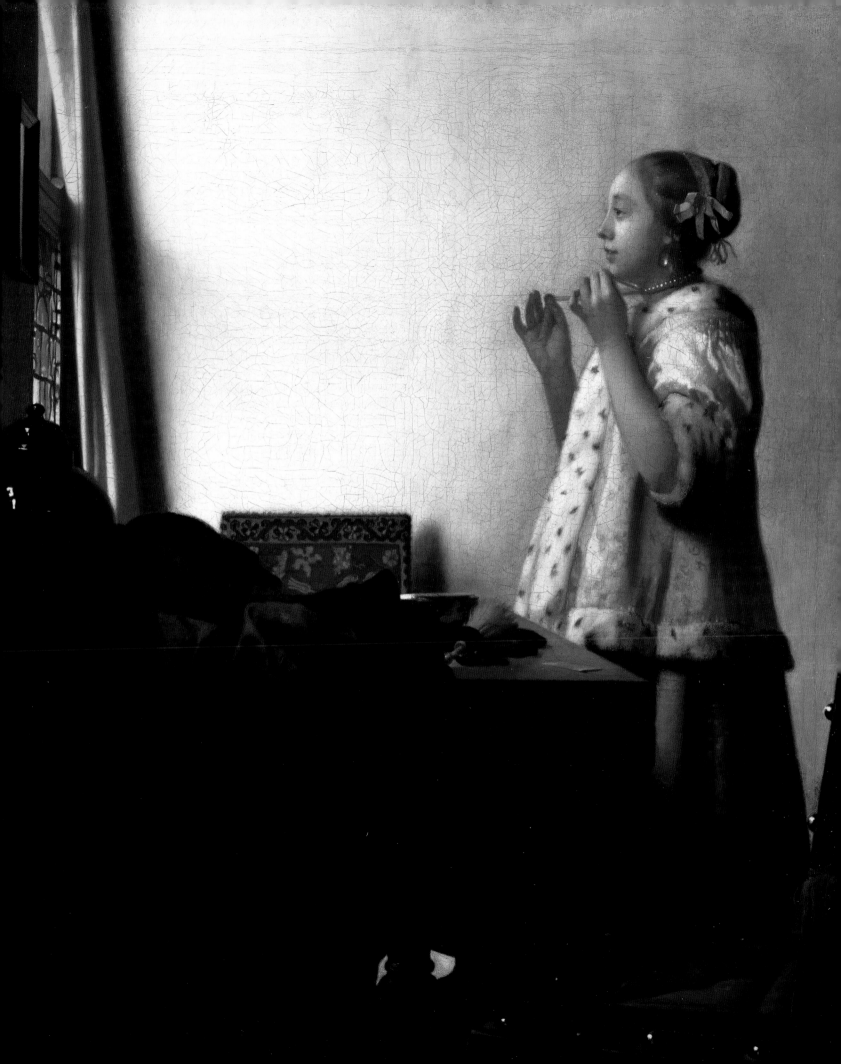

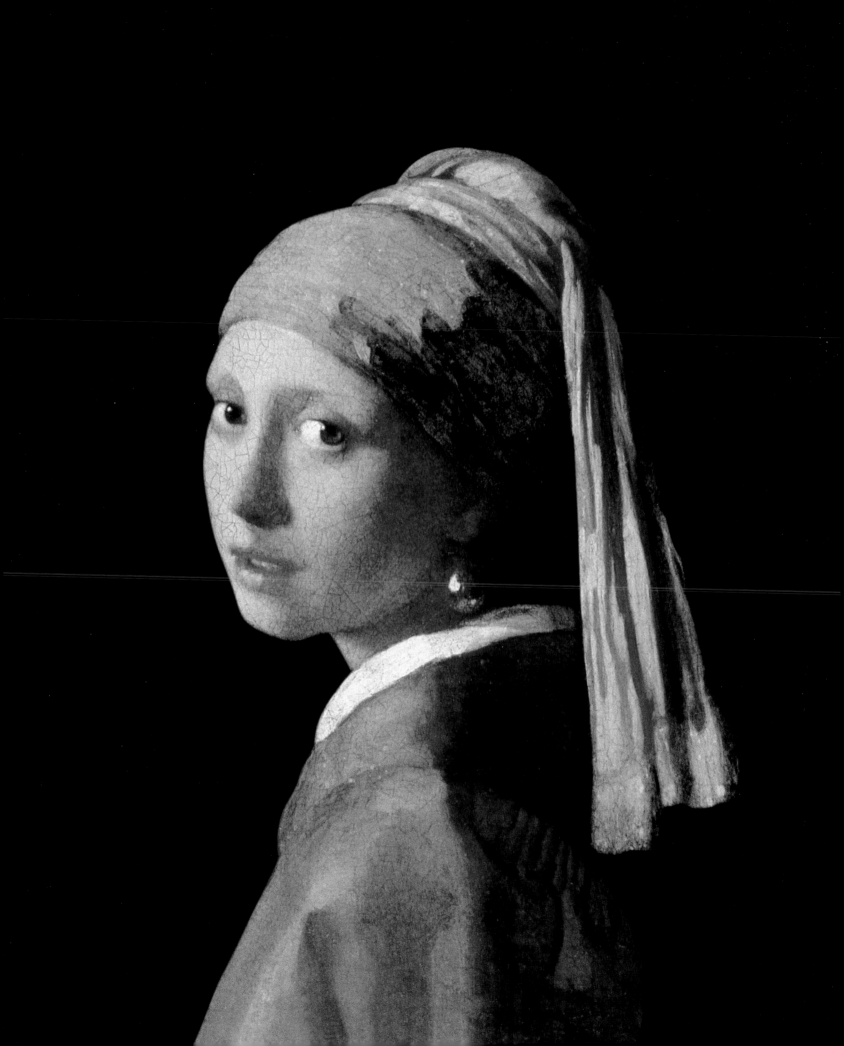

'The Mona Lisa of the North'

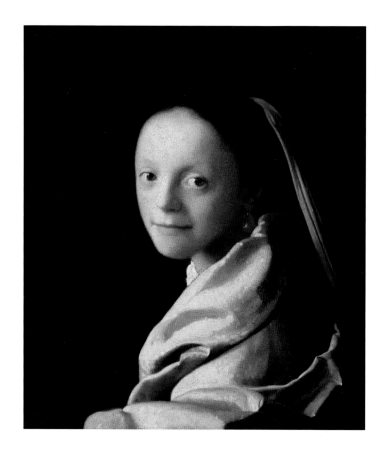

The 'Mona Lisa of the North' is the popular name given to *The Girl with a Pearl Earring*. Her intriguing pose, the expression on her face, her mysterious gaze – everything about the painting troubles us. There are no props, only a dark background verging on black. The young girl wears a blue oriental-style turban, poking out of which is a piece of lemon yellow fabric which tumbles down onto her unadorned jacket. The pearl in her ear illuminates her face and is echoed in the shine of her lips and the glint in her eye. The impression of haziness is achieved through the technique of *sfumato*: by applying a multitude of very thin layers of oil paint, the painter softens the forms and obtains gradations in which shadow and light merge together.

The handling of the two portraits is identical, but the second seems more restrained, more chilly. The smile and the sweetness of the young woman's face suggest naivety, while the pearl is barely visible against the velvety gray of her garment. With these two paintings Vermeer fires our curiosity and lets through an emotion that seems elusive.

The Girl with a Pearl Earring, c. 1665/66 *Study of a Young Woman, c. 1663/65*

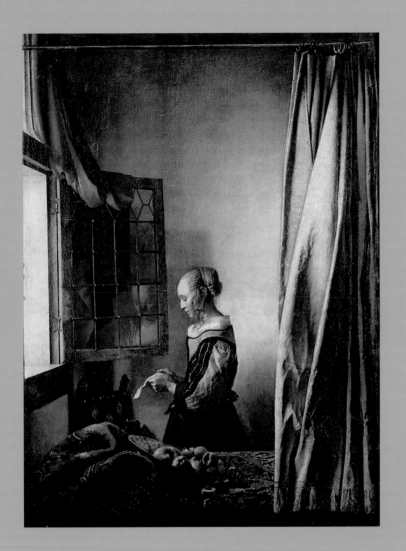

Through the Keyhole

Vermeer is above all a painter of the intimate who tries to harness emotions. He represents people isolated in their private worlds and unlocks their feelings. The viewer thus becomes an observer, examining the characters' gestures and trying to guess their thoughts. We worm our way into the innermost recesses of their lives as if we were sliding an eye through the keyhole so as to steal a secret. Engrossed in the reading of a letter, the two young women both stand in front of the window, a window that in *Woman in Blue* is inferred from the brightness of the wall behind her. As the sole witness to this scene, the viewer has but one wish: to uncover their secret desire and the object of such rapt attention. Could it be a love letter or is it just a simple note?

Woman in Blue Reading a Letter, c. 1663/64

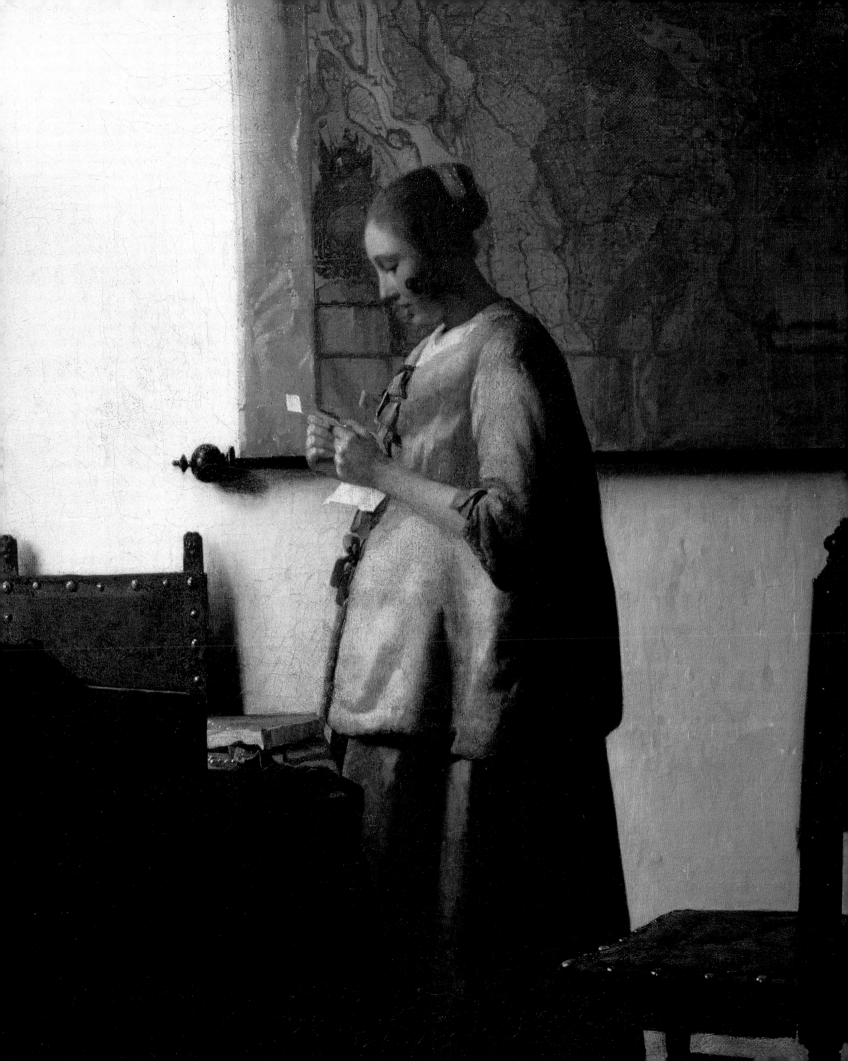

A Lacemaker's Work

The Lacemaker is the smallest of Vermeer's paintings, as if the painter had wanted us to come near so as to observe the young woman's concentration at close quarters. Leaning forward, bent over her work, the piece she is making is partly obscured from view. The colors recall those of *The Milkmaid*, but the contrasts are less stark. The lacemaker's face and hands are distinct, while the foreground is out of focus, and the patterns of the blue rug are hardly delineated. The threads that tumble from the sewing cushion are simple flecks, lines or dots of white or red color. By applying the paint delicately with little brushstrokes, Vermeer creates spots of light which produce the illusion of reality.

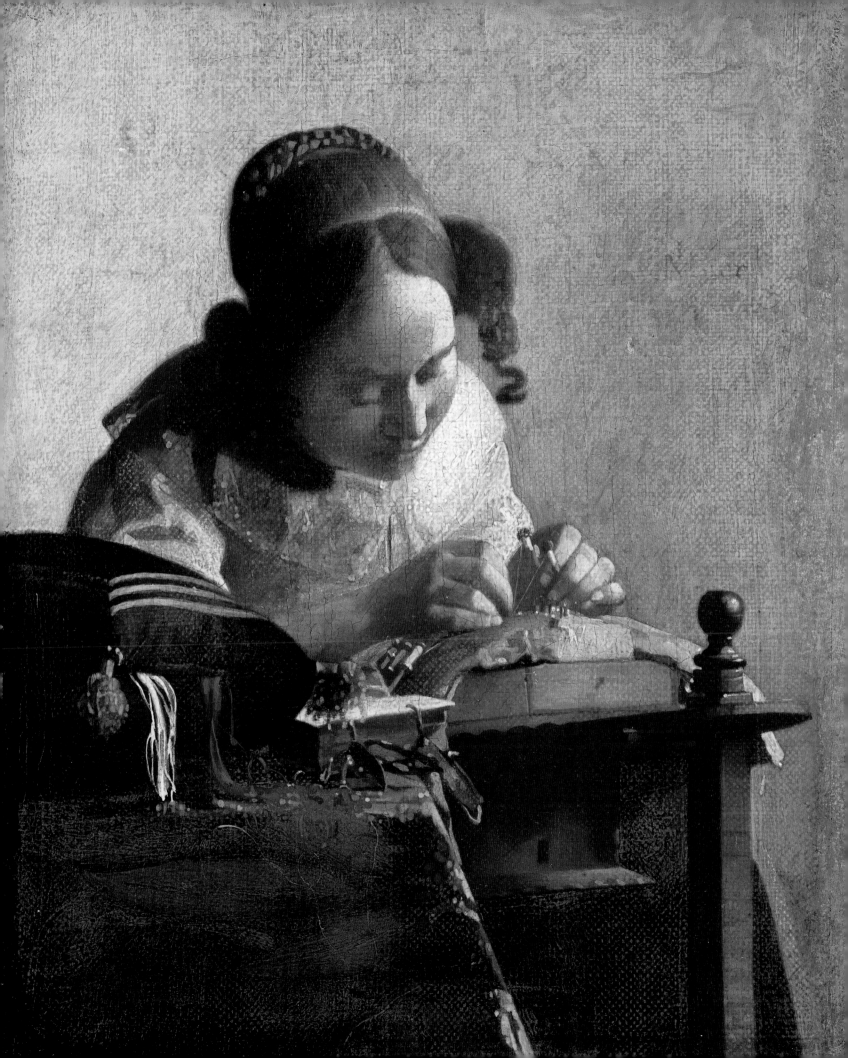

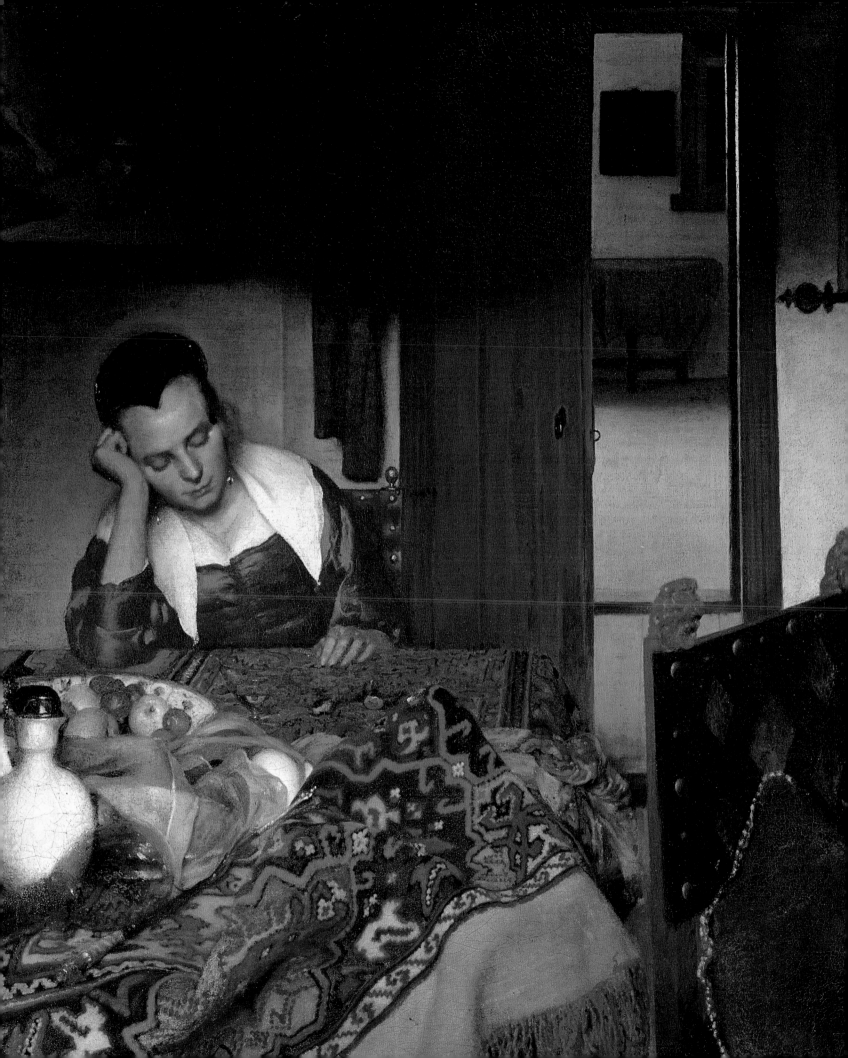

Melancholy and Poetry

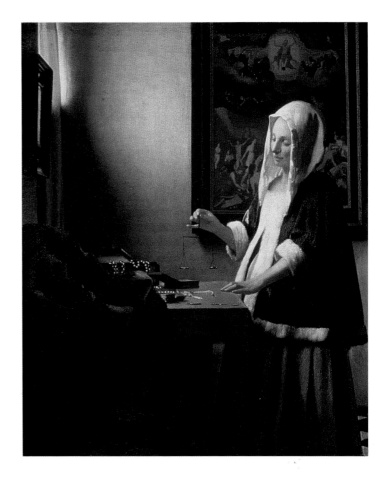

Time passes slowly in Vermeer's paintings. In the uncluttered space of the room, the gold assayer gathers her thoughts as she holds up a set of scales in front of her. A ray of light illuminates her face. The freshness of her skin and the white of her hood contrast with the darkness that surrounds her. The curtain at the window is drawn and conceals her work from the gaze of passers-by. On the table coins are piled up and strings of pearls tumble out of jewelry boxes. With a careful gesture, the young woman holds the scales in perfect balance – yet they are empty. This scene expresses the mystery and poetry that is contained in Vermeer's works. In a mood of melancholy and silence, these figures seem wrapped in solitude. Like the dozing woman lost in her thoughts, something eludes us. Her head resting in her hand, she is plunged into a peaceful sleep. The open door behind her suggests escape, a possible route to the world beyond. But everything remains motionless.

A Maid Asleep, c. 1656/57 *Woman Holding a Balance, 1664* 25

The Art
of Painting

Vermeer also painted allegorical scenes. In *The Art of Painting*, he may have put himself in the picture – in the figure of the artist seen from behind working at his easel. This painting would probably have been commissioned to decorate the walls of the Guild of St Luke, a trade association of which Vermeer was a member. This interior is certainly the painter's own studio, with the same layout and the same furniture that can be seen in other of his paintings: the rugs and hangings, the table and chairs, the black and white floor tiles, the window on the left that is hidden from view. The young girl in the background wears a crown of laurels on her head and carries a book and a trumpet in her hands: this is the trumpet of Fame, which announces glorious feats. The girl is Clio, the Muse of History. The painter is busy drawing her crown, but we see neither his palette nor a set of paintbrushes: only a stick propped against the canvas to steady his hand. This painting is filled with mysteries and secrets. However, without needing to know more, the painting casts its spell, just as does every other work by the Delft master.

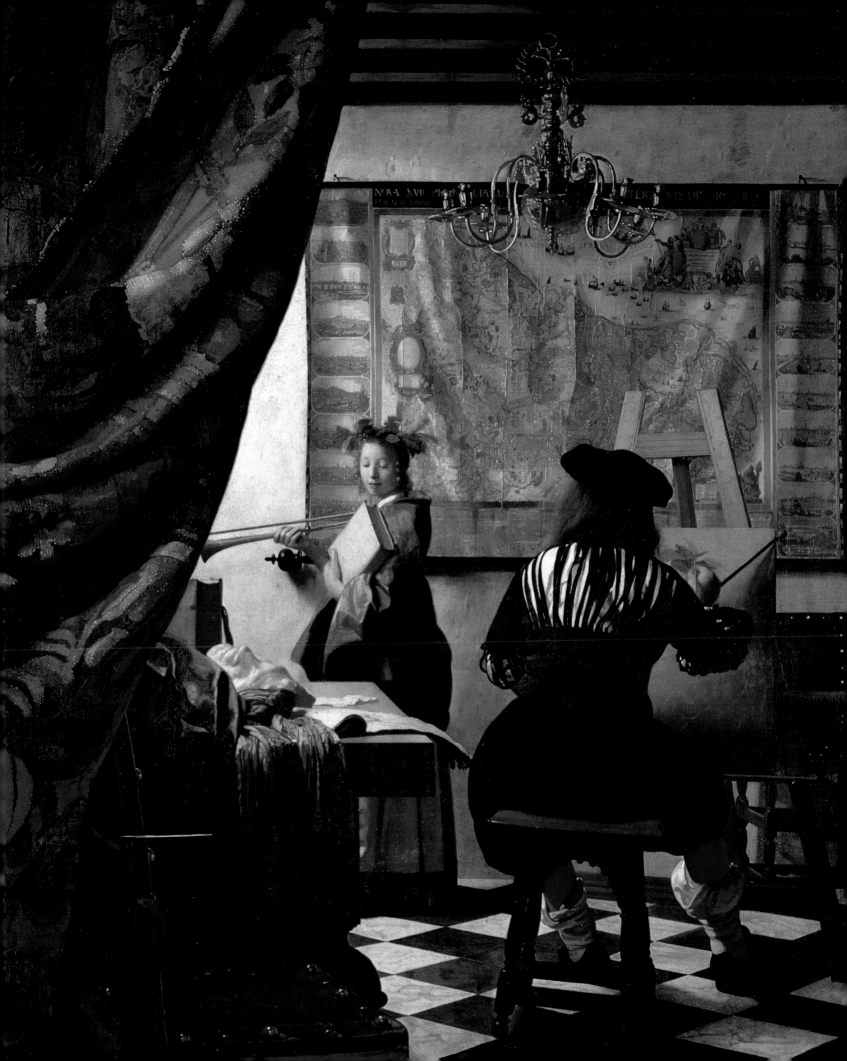

The Life of Jan Vermeer

Vermeer's life is enveloped in mystery, just like his work. He painted little, and only thirty-five canvases are known to us. Since Vermeer was very influential and was much copied, some of his works are still the subject of debate as to their authenticity.

Johannes (or Jan) Vermeer was born in Delft in 1632 and lived there all his life. At the time it was the third largest town in the Netherlands, prosperous through trade and the numerous merchants that crossed paths there. It was also a major center of artistic activity.

Nothing is known about the painter's training other than that he was in contact with well-known artists such as Carel Fabritius, a pupil of Rembrandt. His career only lasted twenty years or so. In 1653 he married Catharina Bolnes and went to live in the house of his mother-in-law, Maria Thins, in the Catholic district of the town. He and Catharina were to have fifteen children, four of whom died in infancy.

In the same year Vermeer was registered as a 'master' of the Guild of St Luke, to which his art dealer father also belonged. This brotherhood included among its members the town's painters, sculptors, glaziers and potters, embroiderers, engravers, bookbinders and printers. By this time Vermeer already enjoyed a considerable reputation.

He painted slowly, one or two canvases per year. These paintings were often the result of commissions, guaranteeing him a regular income – although that didn't stop him experiencing financial difficulties throughout his entire life.

In 1656 he painted *The Procuress*. The figure on the left of the painting is perhaps a self-portrait of the artist. He may have represented himself in the guise of a musician, his face in shadow, throwing an amused glance towards the viewer.

Vermeer died at the age of forty-three, in 1675, leaving behind a rare body of work that would be put up for auction in 1696 by his wife in order to pay off the couple's debts. Forgotten in the eighteenth century, Vermeer was rediscovered in the following century by artists such as Vincent van Gogh and the writer Marcel Proust.

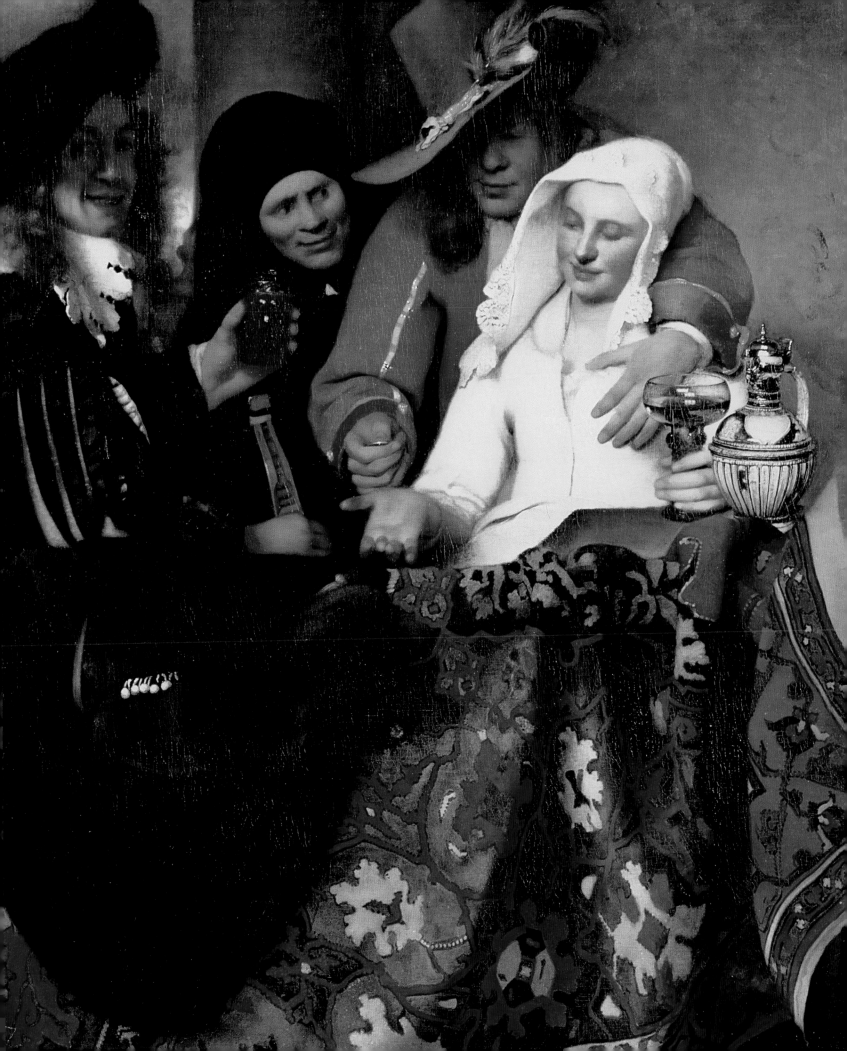

Front cover
- *The Girl with a Pearl Earring* (detail), c. 1665/66. Oil on canvas, 44.5 x 39 cm. Royal Picture Gallery, Mauritshuis, The Hague, Netherlands. © The Bridgeman Art Library.

Title page
- *The Geographer*, 1669. Oil on canvas, 53 x 46.6 cm. Städelsches Kunstinstitut, Frankfurt am Main, Germany. © AKG-images.

pages 2–3
- *View of Delft, c.* 1660/61. Oil on canvas, 96.5 x 117.5 cm. Royal Picture Gallery, Mauritshuis, The Hague, Netherlands. © The Bridgeman Art Library.

pages 5
- *Young Woman with a Water Pitcher, c.* 1662. Oil on canvas, 45.7 x 40.6 cm. Metropolitan Museum of Art, New York, USA. Marquand Collection, Gift of Henry G. Marquand, 1889. © The Bridgeman Art Library.

pages 6–7
- *A Young Woman Seated at a Virginal*, 1672. Oil on canvas, 51.4 x 45.7 cm. National Gallery, London, UK. © AKG-images.
- *The Concert, c.* 1658/60. Oil on canvas, 69 x 63 cm. Isabella Stewart Gardner Museum, Boston, USA. © AKG-images.
- *The Girl with a Wineglass, c.* 1659/60. Oil on canvas, 77 x 66 cm. Herzog Anton Ulrich-Museum, Brunswick, Germany. © AKG-images.

pages 8–9
- *A Lady Writing*, 1665. Oil on canvas, 45 x 39 cm. National Gallery of Art, Washington, D.C., USA. Gift of Harry Waldron Havemeyer and Horace Havemeyer Jr. © AKG-images.
- *A Young Woman Standing at a Virginal, c.* 1672/73. Oil on canvas, 51.7 x 45.2 cm. National Gallery, London, UK. © The Bridgeman Art Library.

pages 10–11
- *A Woman Writing a Letter with her Maidservant, c.* 1670. Oil on canvas, 72.2 x 59.5 cm. National Gallery of Ireland, Dublin. © The Bridgeman Art Library.
- *Woman with a Lute*, 1664. Oil on canvas, 51.4 x 45.7 cm. Metropolitan Museum of Art, New York, USA. Bequest of Collis P. Huntington, 1900. © The Bridgeman Art Library.

pages 12–13
- *The Geographer*, 1669. Oil on canvas, 53 x 46.6 cm. Städelsches Kunstinstitut, Frankfurt am Main, Germany. © AKG-images.
- *The Astronomer* (also called *The Astrologer*), 1668. Oil on canvas, 51 x 45 cm. Musée du Louvre, Paris. © Photo RMN – © René-Gabriel Ojéda.

pages 14–15
- *The Milkmaid, c.* 1658/60. Oil on canvas, 45.4 x 40.6 cm. Rijksmuseum, Amsterdam, Netherlands. © The Bridgeman Art Library.

pages 16–17
- *Woman with a Pearl Necklace, c.* 1662/65. Oil on canvas, 55 x 45 cm. Staatliche Museen zu Berlin, Gemäldegalerie, Berlin, Germany. © BPK, Berlin, Dist. RMN – © Jörg P. Anders.

pages 18–19
- *The Girl with a Pearl Earring, c.* 1665/66. Oil on canvas, 44.5 x 39 cm. Royal Picture Gallery, Mauritshuis, The Hague, Netherlands. © The Bridgeman Art Library.
- *Study of a Young Woman, c.* 1663/65. Oil on canvas, 44 x 40 cm. Metropolitan Museum of Art, New York, USA. © The Bridgeman Art Library.

pages 20–21
- *Girl Reading a Letter by an Open Window*, 1659. Oil on canvas, 83 x 64.5 cm. Staatliche Kunstsammlungen, Gemäldegalerie Alte Meister, Dresden, Germany. © AKG-images – Erich Lessing.
- *Woman in Blue Reading a Letter, c.* 1663/64. Oil on canvas, 46.5 x 39 cm. Rijksmuseum, Amsterdam, Netherlands. © The Bridgeman Art Library.

pages 22–23
- *The Lacemaker*, 1670. Oil on canvas mounted on wood, 24 x 31 cm. Musée du Louvre, Paris. © Photo RMN – © René-Gabriel Ojéda.

pages 24–25
- *A Maid Asleep, c.* 1656/57. Oil on canvas, 87.6 x 76.5 cm. Metropolitan Museum of Art, New York, USA. Bequest of Benjamin Altman, 1913. © The Metropolitan Museum of Art / Art Resource, New York.
- *Woman Holding a Balance*, 1664. Oil on canvas, 42.5 x 38 cm. National Gallery of Art, Washington, D.C., USA. © The Bridgeman Art Library.

pages 26–27
- *The Artist's Studio* or *The Art of Painting, c.* 1665/66. Oil on canvas, 120 x 100 cm. Kunsthistorisches Museum, Vienna, Austria. © 2006. Photo Austrian Archive / Scala, Florence.

pages 28–29
- *The Procuress*, 1656. Oil on canvas, 143 x 130 cm. Staatliche Kunstsammlungen, Gemäldegalerie Alte Meister, Dresden, Germany. © The Bridgeman Art Library.

Back cover
- *The Artist's Studio* or *The Art of Painting, c.* 1665/66. Oil on canvas, 120 x 100 cm. Kunsthistorisches Museum, Vienna, Austria. © 2006. Photo Austrian Archive / Scala, Florence.

© Prestel Verlag,
Munich · Berlin · London · New York 2008
© for the original French edition:
Edition Palette…, Paris 2008

Prestel Verlag
Königinstrasse 9
80539 Munich
Tel. +49 (0)89 24 29 08-300
Fax +49 (0)89 24 29 08-335

Prestel Publishing Ltd.
4 Bloomsbury Place
London WC1A 2QA
Tel. +44 (0)20 7323-5004
Fax +44 (0)20 7636-8004

Prestel Publishing
900 Broadway, Suite 603
New York, N.Y. 10003
Tel. +1 (212) 995-2720
Fax +1 (212) 995-2733

www.prestel.com

Prestel books are available worldwide. Please contact your nearest bookseller or one of the above addresses for information concerning your local distributor.

The Library of Congress Cataloguing-in-Publication data is available.
British Library Cataloguing-in-Publication Data: a catalogue record for this book is available from the British Library. The Deutsche Bibliothek holds a record of this publication in the Deutsche Nationalbibliografie; detailed bibliographical data can be found under: http://dnb.ddb.de

Translated from the French
by Sarah Kane, Watford
Design and layout by Loïc Le Gall

Printed in Italy on acid-free paper

ISBN 978-3-7913-3987-0